Windsor Ontario Book 2 in Colour Photos, Saving Our History One Photo at a Time

Photography
by Barbara Raué
2015

Series Name:
Cruising Ontario

Book 118: Windsor Book 2
Victoria Avenue

Cover photo: 942 Victoria Avenue (Page 29)

Series Name: Cruising Ontario
Saving Our History One Photo at a Time
in colour photos

Books Available in Alphabetical Order:
Aberfoyle, Acton, Alton, Ancaster, Arthur, Aylmer, Ayr, Bloomingdale, Brantford, Burlington, Caledon, Caledonia, Cambridge, Clifford, Conestogo, Delhi, Dorchester to Aylmer, Drayton, Drumbo, Dundas, Eden Mills, Elmira, Elora, Fergus, Guelph, Hagersville, Hamilton, Hanover, Harriston, Hespeler, Jarvis, Kitchener, Linwood, Listowel, London, Lucknow, Mono, Mount Forest, Neustadt, New Hamburg, Niagara-on-the-Lake, Oakville, Orangeville, Orillia, Owen Sound, Palmerston, Peterborough, Port Elgin, Preston, Rockwood, Seaforth, Sheffield, Shelburne, Simcoe, Southampton, St. Jacobs, St. Thomas, Stoney Creek, Stratford, Tillsonburg, Waterdown, Waterrford, Waterloo, Wellesley, Wingham

Book 110:Lucknow,Mitchell
Book 111: Conestogo, Bloomingdale
Book 112: Delhi
Book 113: Waterford
Book 114-116: Waterloo
Book 117-119: Windsor

Other Books by Barbara Raue

Coins of Gold

Arrows, Indians and Love

The Life and Times of Barbara
Volume 1: Inventions That Have Enhanced My Life
Volume 2: Entertainment That I Have Enjoyed
Volume 3: East Coast Trips
Volume 4: Olympics Have Always Intrigued Me
Volume 5: Wonders of the World
Volume 6: Caribbean Cruises We Have Enjoyed
Volume 7: Animals
Volume 8: Storms and Other Major Disasters in My Lifetime
Volume 9: Wars, Terrorist Attacks and Major Disasters

The Cromwell Family Book

Laura Secord Discovered

Daddy Where Are You?

Visit Barbara's website to view all of her books
http://barbararaue.ca

Windsor is the southernmost city in Canada. The Detroit River is to the north of the city, which separates it from Detroit, Michigan. Windsor was settled by the French in 1749 as an agricultural settlement. In 1794, after the American Revolution, the settlement of "Sandwich" was founded. It was later renamed Windsor, after the town in Berkshire, England.

Ouellette Avenue is the historic main commercial street in downtown Windsor running north-south perpendicular to the Detroit River, and divides the city into east and west sections. Windsor has 180 parks and maintains forty miles of trails.

In 1701, Sieur de Lamothe Cadillac is sent to establish Fort Pontchartran on the north side of what is now Detroit River. In 1749, the Governor of Quebec initiates development on the south shore. He sends 20 French families from Quebec to clear the land for farms and homes. At least 25 lots are surveyed along the river.

Windsor Barracks (1840 & 1866)

In response to an American threat the British want to improve their defenses along the American border. In 1840, they purchase the land (now City Hall Square) for a military reserve and erect a barracks. In 1849, the government abandons the barracks and the property is used as a refugee center for Blacks who were moving into the area via the "Underground Railroad." In 1859, the Town of Windsor purchases City Hall Square with plans for a park. In 1866, the threat of Fenian raids from Detroit prompts the government to re-claim the property and a new series of barracks is erected.

Central School Square (1871)

After the barracks were abandoned by the military, some of the buildings were used as classrooms. In 1871, the old facilities prove inadequate and a new school is built north of the barracks with students begin classes in the new school building in 1873. The government passes a law requiring all children ages 7-12 to attend school.

Windsor's economy is primarily based on manufacturing, tourism, education, and government services. The city is one of Canada's major automobile manufacturing centers and is home to the headquarters of FCA Canada (Chrysler) with its minivan assembly plant, two Ford Motor Company engine plants, and several tool and die and automotive parts manufacturers. Caesars Windsor opened in 1994, one of the largest casinos in Canada, and is one of the largest local employers.

Detroit, Michigan

Detroit is in the U.S. state of Michigan and is the largest city on the United States-Canada border. It is a major port on the Detroit River, a strait that connects the Great Lakes system to the Saint Lawrence Seaway. It was founded on July 24, 1701, by the French explorer and adventurer Antoine Laumet de La Mothe, sieur de Cadillac and a party of settlers. Detroit is known as the world's automotive center with the two familiar nicknames, the *Motor City* and Motown.

Victoria Avenue

James Dougall, the developer of Victoria Avenue, was born in Paisley, Scotland in 1810, and arrived in Windsor in 1830 to establish the first general store in the region. Two years later he married Susanne Baby whose grandfather, Jacques Duperon Baby, owned the large tract of farmland, which was to become the core of today's City of Windsor. Dougall's general store, "Dougall's Emporium", stood on Sandwich Street (now Riverside Drive West) near the present Cleary International Centre. Land speculation grew in Windsor as a result of the arrival of the Great Western Railroad.

From the outset, Victoria Avenue was intended to be a gracious, residential street. The Windsor Land and Building Company placed conditions on buyers of building lots, which stipulated a minimum setback of 20 feet, a house value of at least $3,000 (considerable for that time), and assurance that any business carried on would not be deemed a nuisance on a private residential street.

The earliest houses, built between 1890 and the Stock Market "Crash" of 1929, show diversity of design, quality of material, and fine workmanship. They were the valued residences of some of the most influential and respected families during this middle period in Windsor's growth - doctors, merchants, lawyers, educators, politicians and industrialists whose ideas molded this municipality.

French Settlement of the South Shore

Windsor is the oldest known site of continuous settlement in Ontario. The government of New France, anxious to increase its presence on the Detroit River, offered land for agricultural settlement on the south shore in 1749. That summer families from the lower St. Lawrence River relocated to lots which began about 6.5 kilometres downstream from here. Along with civilians and discharged soldiers from Fort Pontchartrain (Detroit), they formed the community of La Petite Cote. Additional waterfront lots were laid out in 1751. They extended from the Huron Mission, located in the vicinity of the present Ambassador Bridge to the Ottawa village situated opposite the fort. When the French regime ended in 1760, about 300 settlers were living here.

Herb Gray

Herb Gray represented the west side of Windsor in the House of Commons from June 1962 to January 2002. He was elected thirteen consecutive times. He served as Deputy Prime Minister from June 1997 to January 2002 and in ten other cabinet positions.

Table of Contents

Victoria Avenue	Page 9
Dougall	Page 33
Ouellette Avenue	Page 42
Detroit, Michigan	Page 43
Architectural Terms	Page 48
Building Styles	Page 52

Victoria Avenue

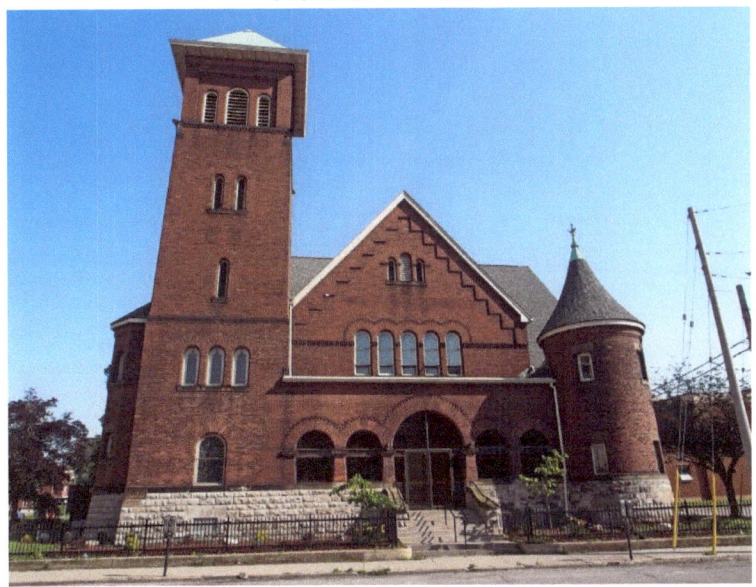

405 Victoria Avenue - St. Andrew's Presbyterian Church – 1896 - Romanesque Revival style, bell tower, turret

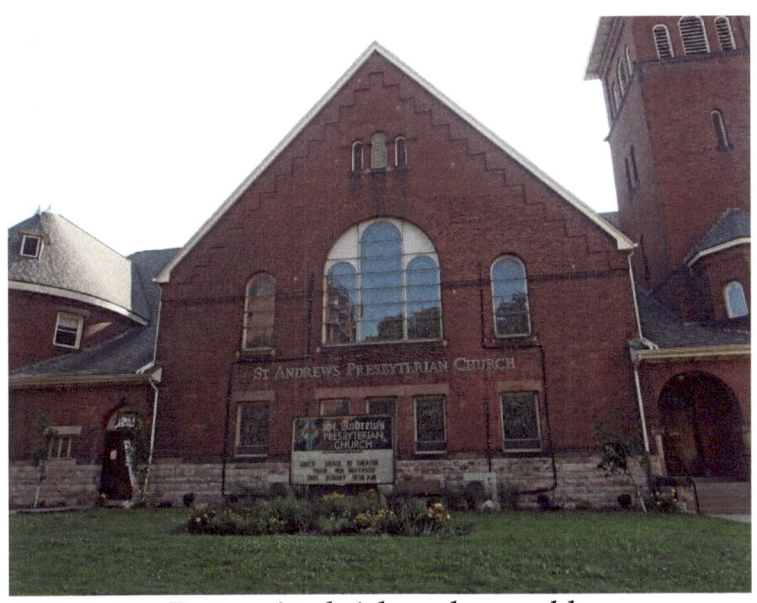

Decorative brickwork on gable

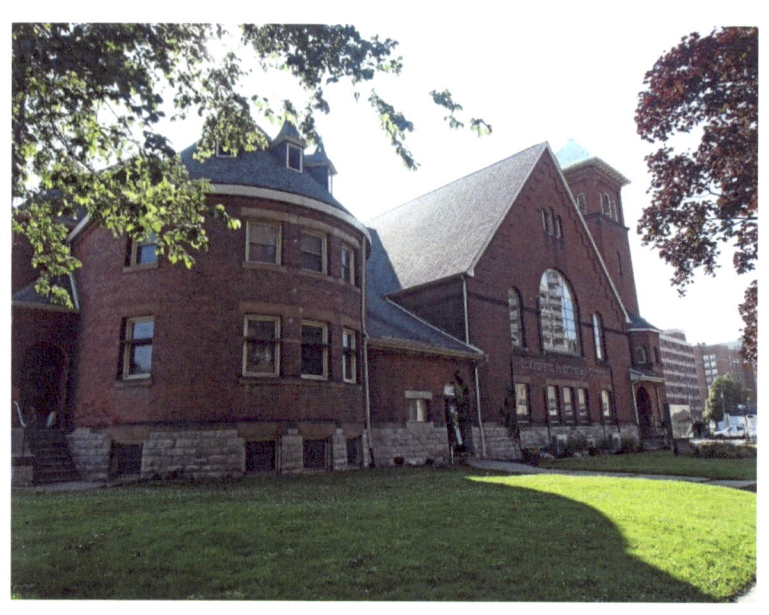

345 Victoria Avenue – Casa Bianca Restaurant
Queen Anne Revival style - 1896

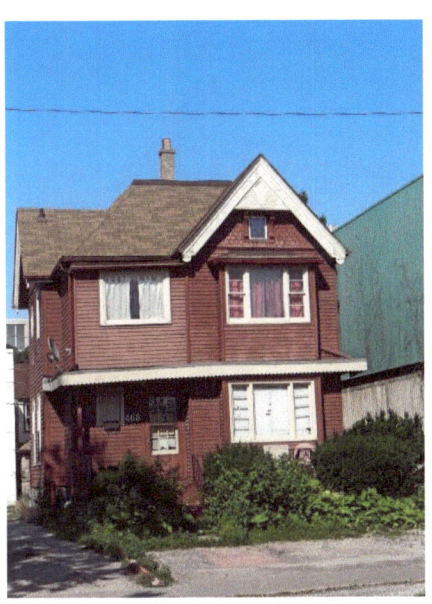

468 Victoria Avenue
Vernacular

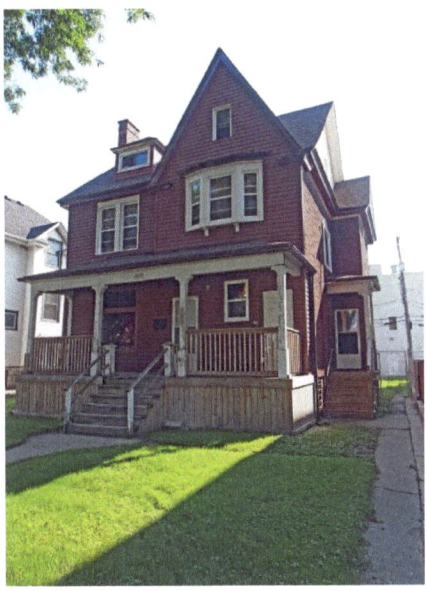

627 Victoria Avenue
Queen Anne Revival style dormer

Italianate style – dormers in attics

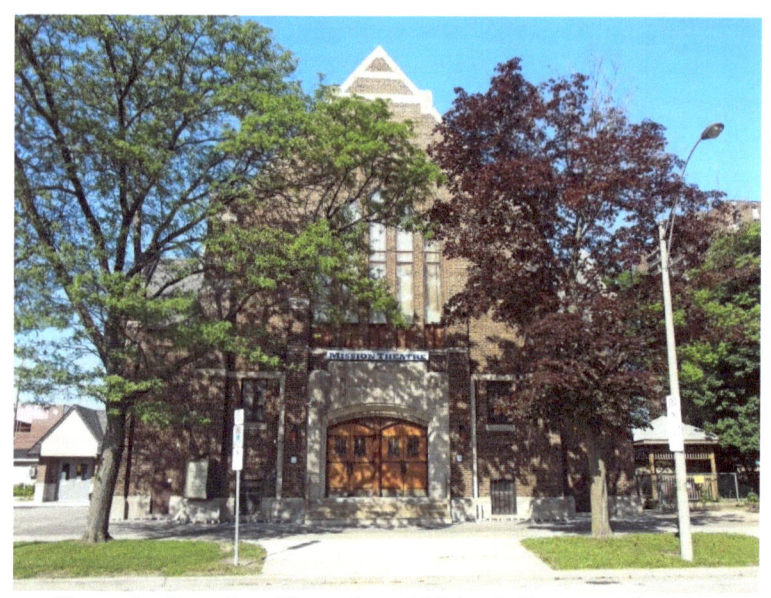

Temple Baptist Church – 1924 – Mission Theatre
Modified Gothic Revival blends with Arts and Crafts characteristics in brick and stone
664 Victoria Avenue

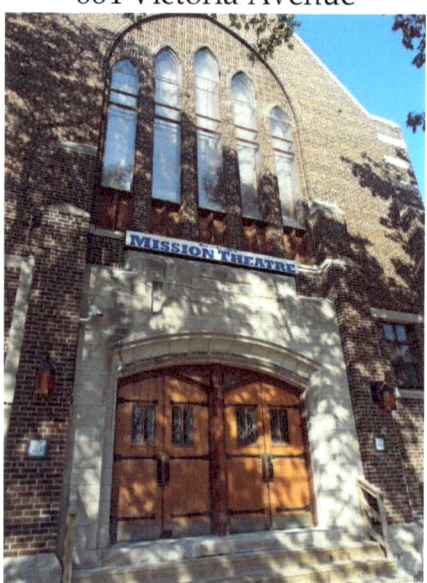

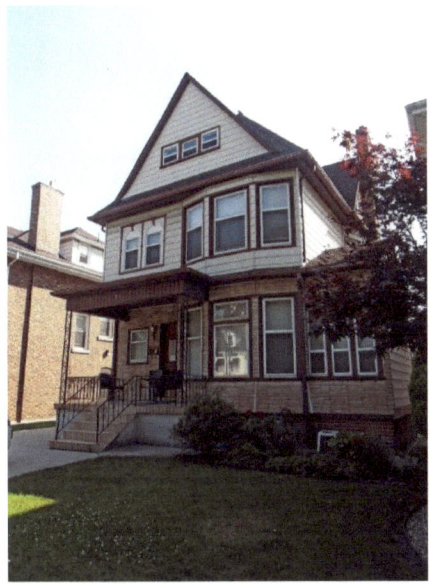

685 Victoria Avenue - Queen Anne Revival style with dominant gable and angled two-storey bay – 1895

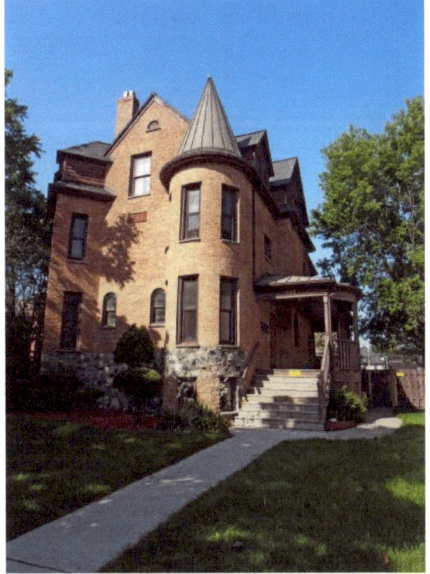

694 Victoria Avenue - Queen Anne Revival style with Romanesque influence, 1890-95; cone-capped turret, cyclopean stone detail (stone construction marked by the use of large irregular blocks without mortar), ornamental terra cotta insert

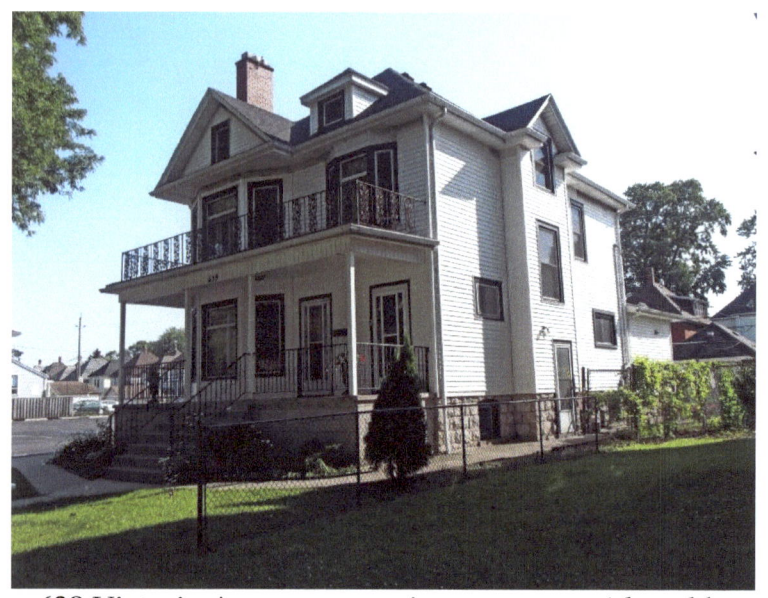

639 Victoria Avenue – cornice return on side gable
Edwardian style, dormer in attic

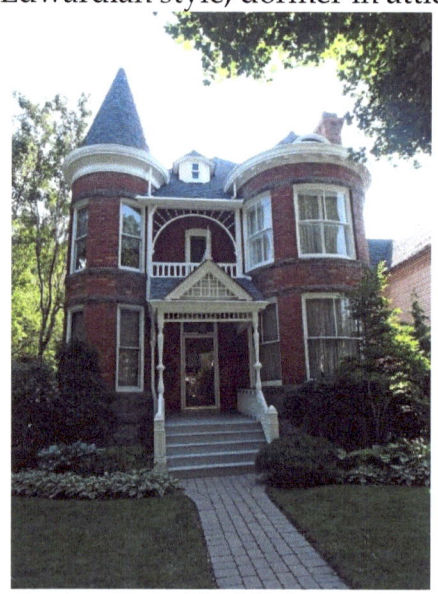

719 Victoria Avenue - Treble-Large House – 1895
Queen Anne Revival style

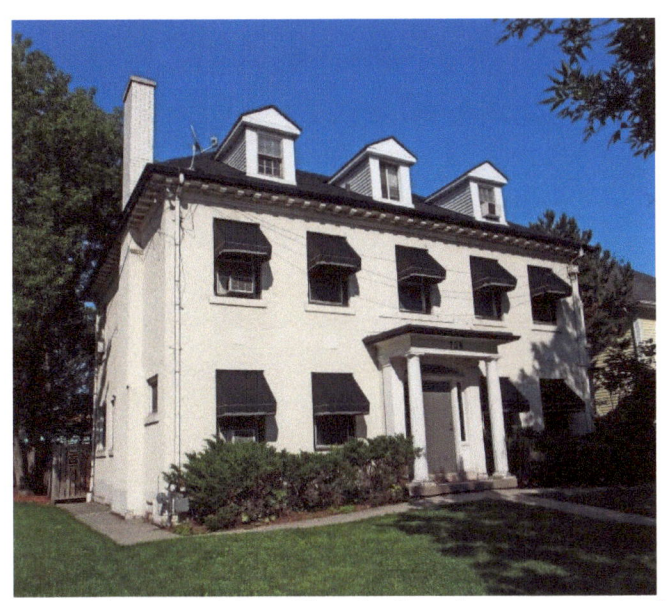

706 Victoria Avenue – Neo-Classical style, symmetrical façade with a prominent columned entry porch sheltering the fanlight and sidelights of the paneled door; dentiled eaves, dormers in attic

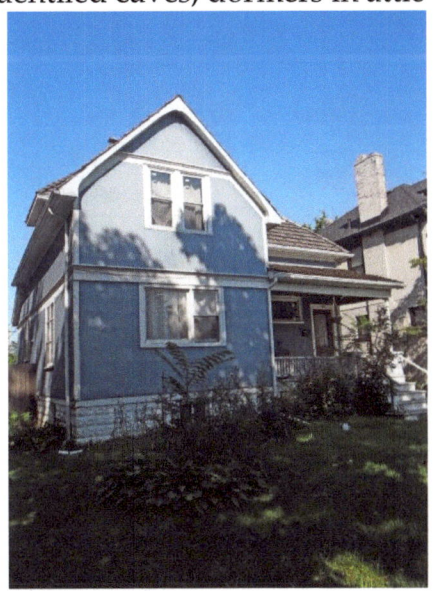

754 Victoria Avenue - Gothic Revival style

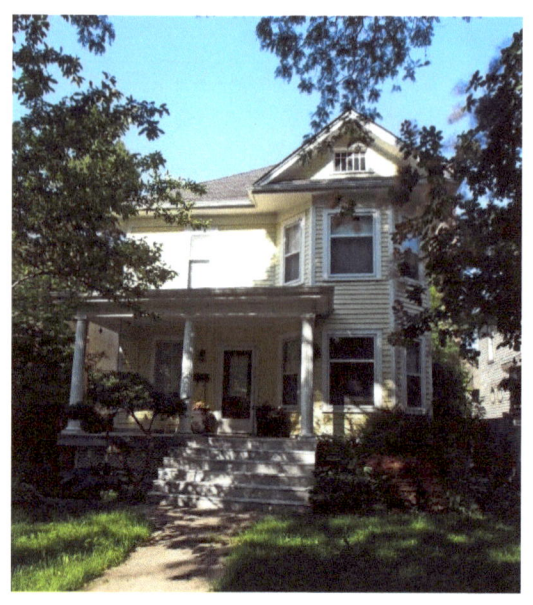

716 Victoria Avenue – vernacular - 1911

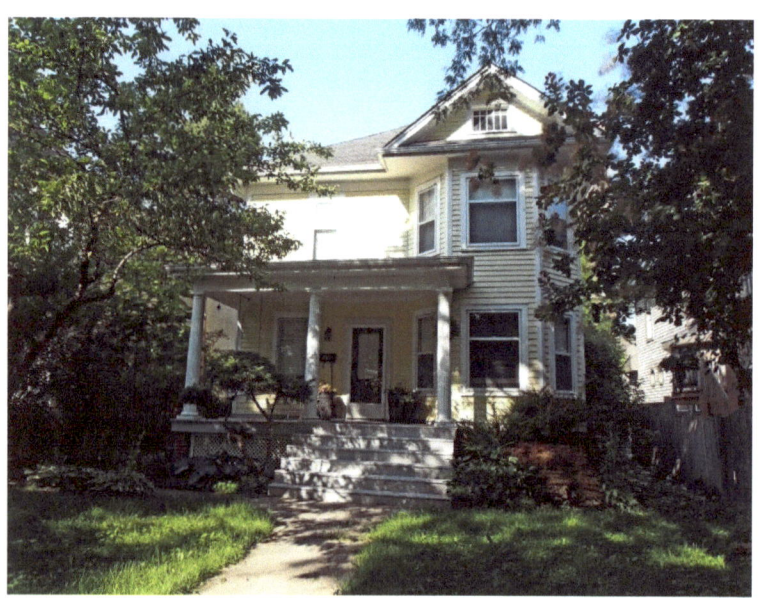

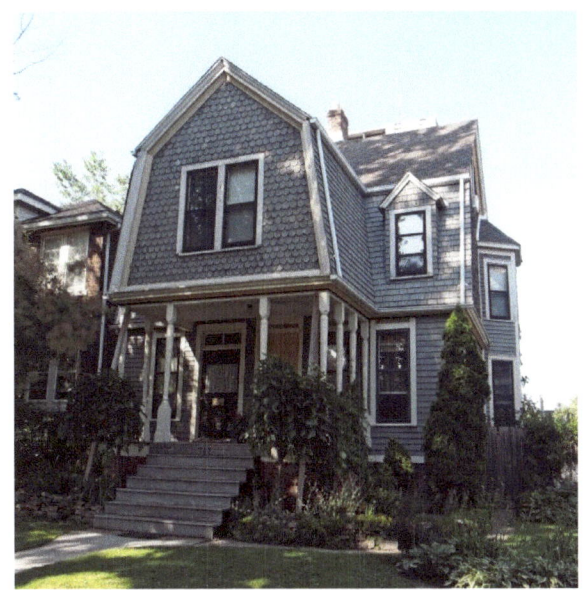

742 Victoria Avenue – Taylor-Growe House – built 1892 - two-storey, Dutch Colonial Revival style with a gambrel roof, and clad in a wooden clapboard finish, fish scale shingles on front façade - symmetrical design, an upper storey that overhangs the columned entry porch

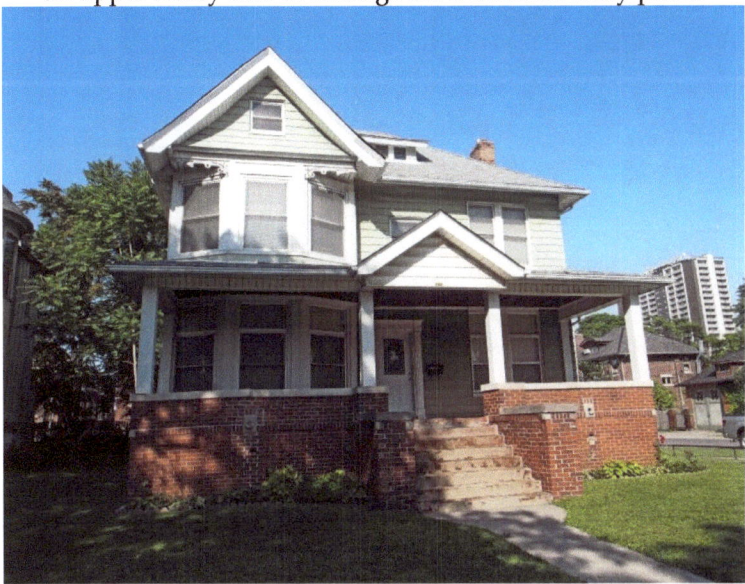

782 Victoria Avenue – Arts and Crafts – flared gables, wooden brackets, ornamental brickwork in south chimney

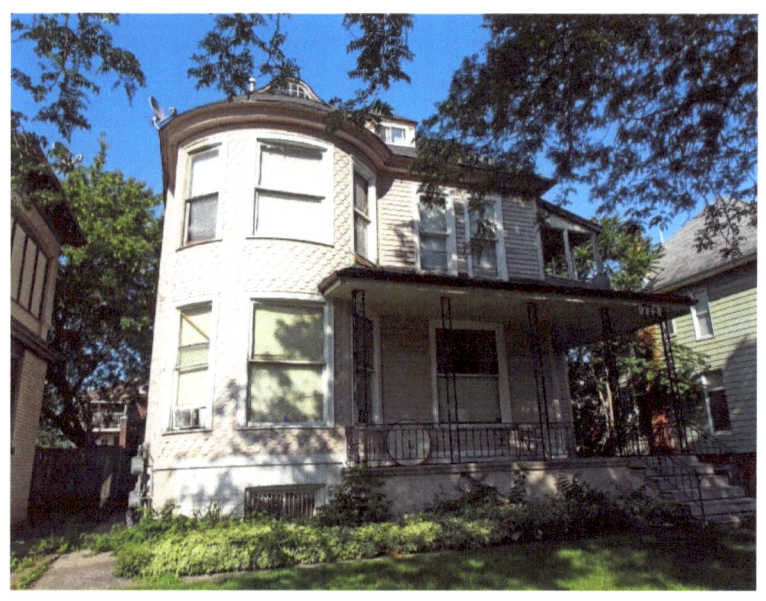

772 Victoria Avenue – Queen Anne style – ornamental brick chimney, shingled bay, small eyebrow window in the roof

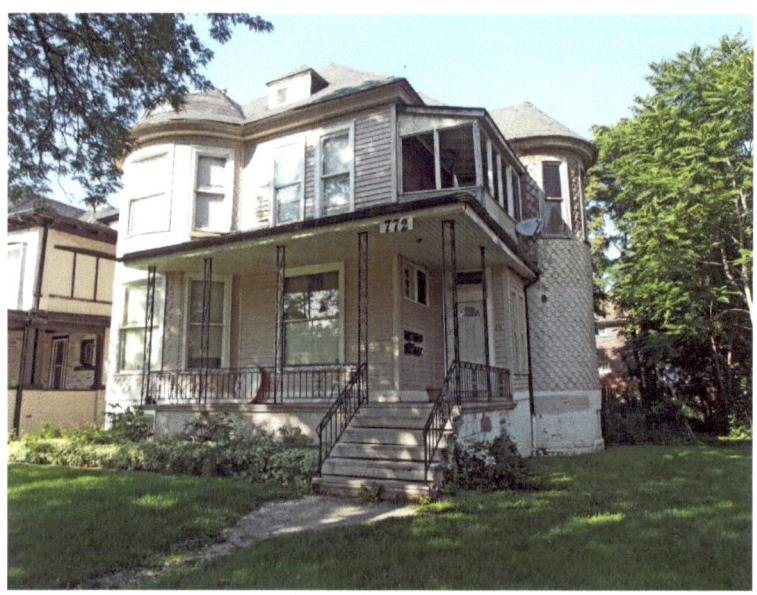

Turrets, second floor balcony, dormer in attic

801 Victoria Avenue – symmetrical portal with sidelights and tripartite transom, dentiled cornice, 2½ storey bay window, dormers - 1914

806 Victoria Avenue – Romanesque characteristics, stone window arches, buttresses on side wall, turret, two-storey verandah

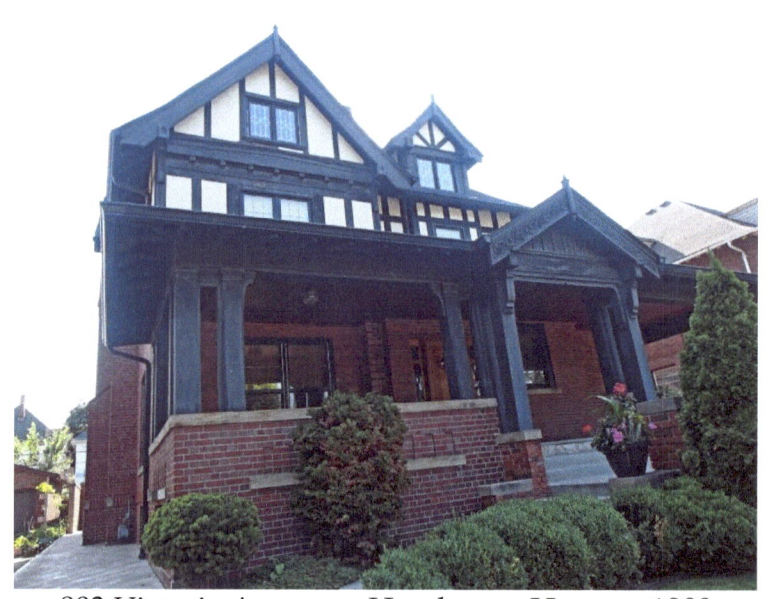

803 Victoria Avenue – Henderson House – 1900
Arts and Crafts Tudor Revival style – sidelights around front door, carved verge boards, finials on gables, massive roofed porch

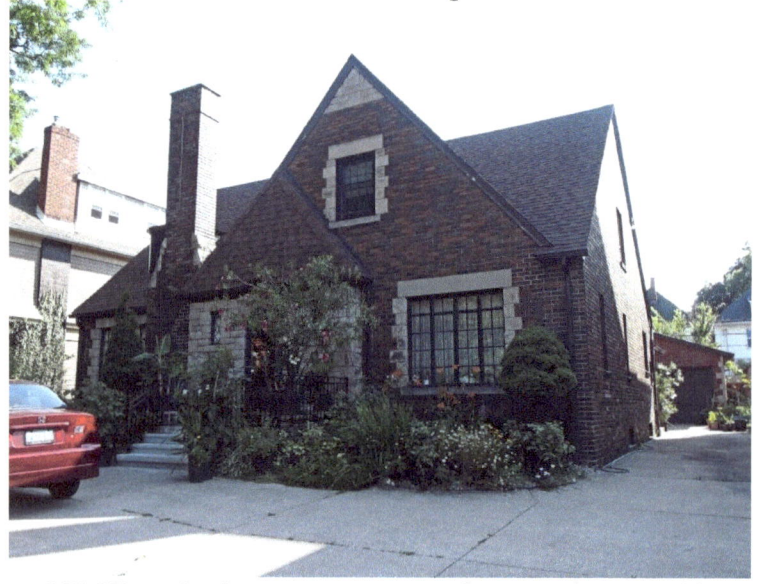

815 Victoria Avenue – vernacular, Jacobean gable

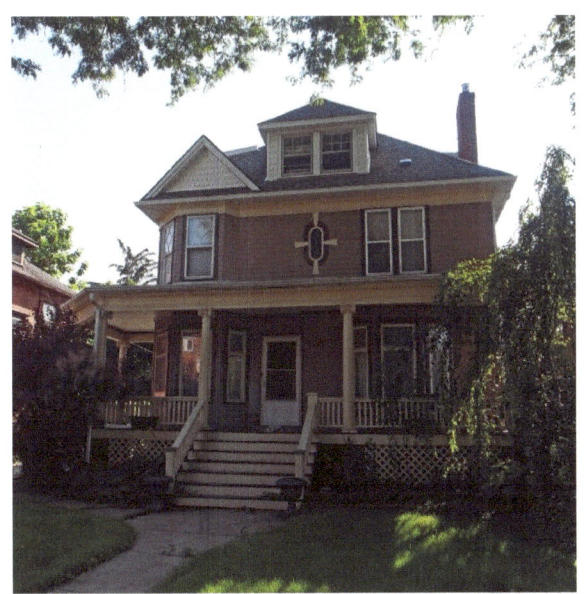

825 Victoria Avenue – "four square" house with Queen Anne detailing, dormer - 1899

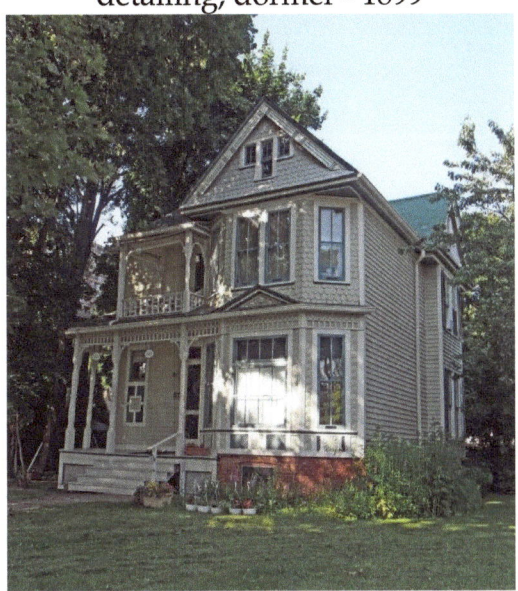

824 Victoria Avenue – a blend of Queen Anne, Shingle and Eastlake features enliven the façade - Palladian window, second floor balcony, pediment with decorated tympanum, fish scale shingles - 1895

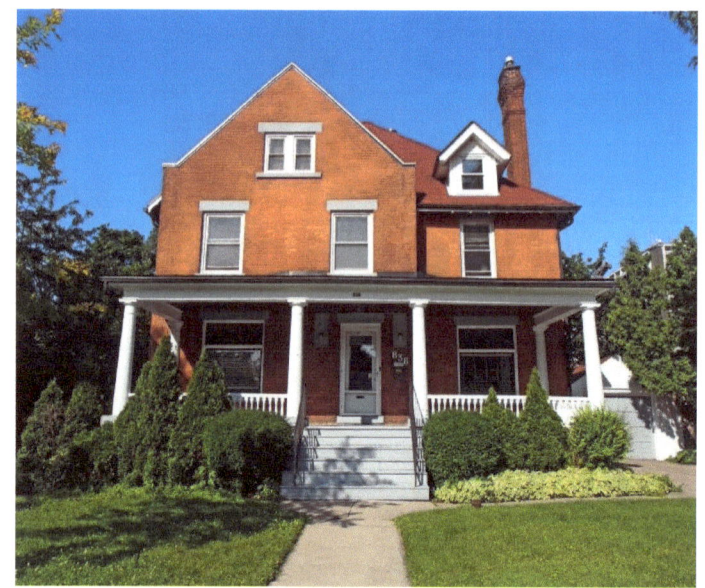

838 Victoria Avenue – 1906 - vernacular, dormer in attic, "Jacobean" gable on the left (rises above the roof line), 6-columned wooden porch, decorative chimney, dormer

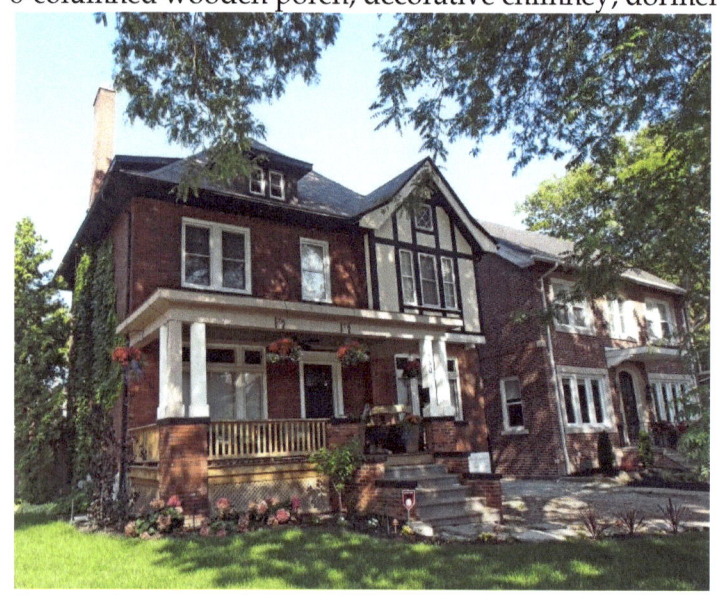

850 Victoria Avenue – Arts and Crafts – red brick with stone trim, Craftsman style wooden porch, brackets, quasi half-timbering over the bay

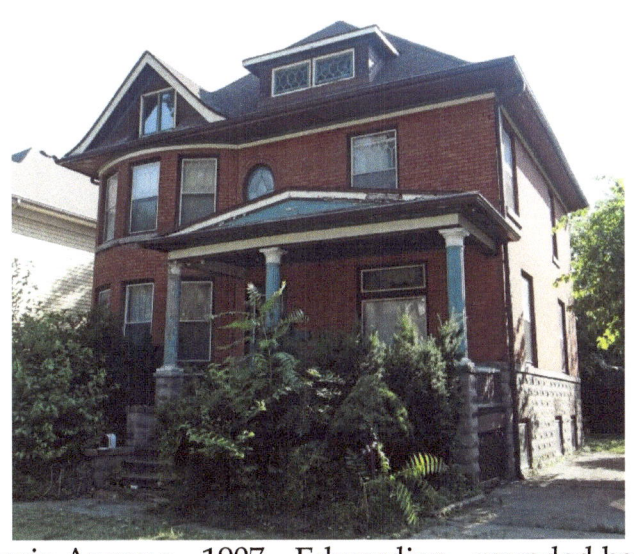

849 Victoria Avenue – 1907 – Edwardian - rounded bay, flared eaves, a columned porch with pediment, dormer, hipped roof, red brick with stone trim

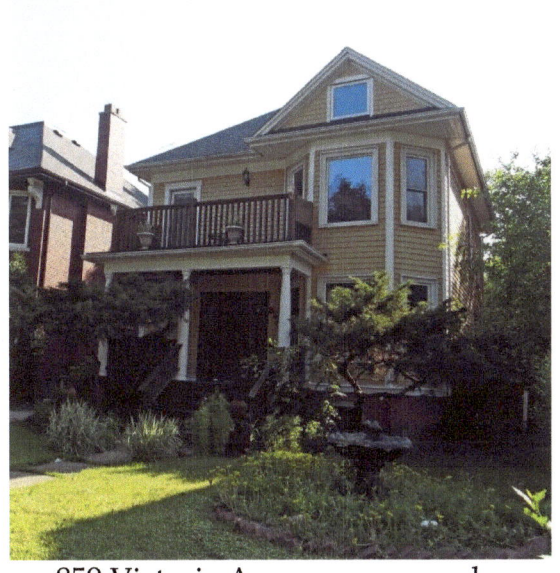

859 Victoria Avenue - vernacular

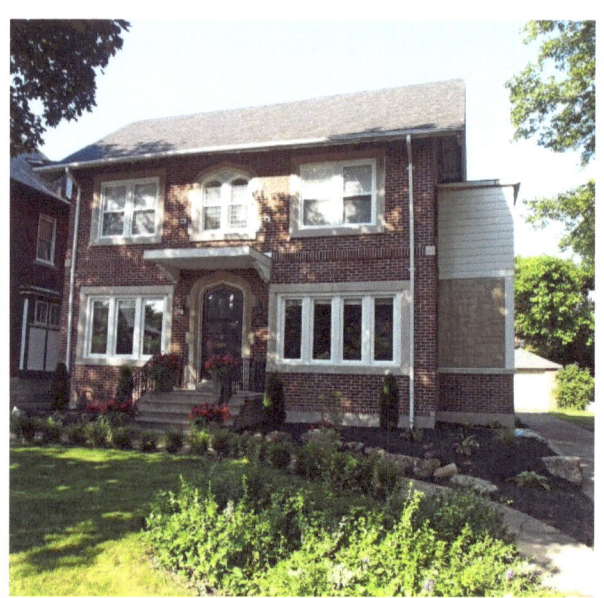

860 Victoria Avenue

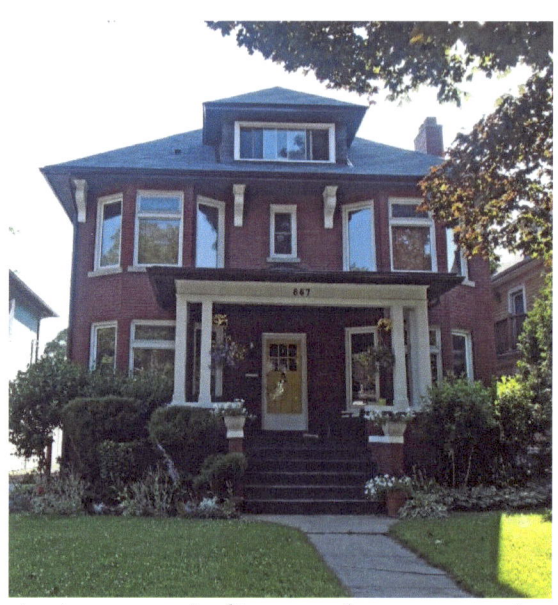

867 Victoria Avenue – Italianate, dormer, cornice brackets, two-storey bay windows

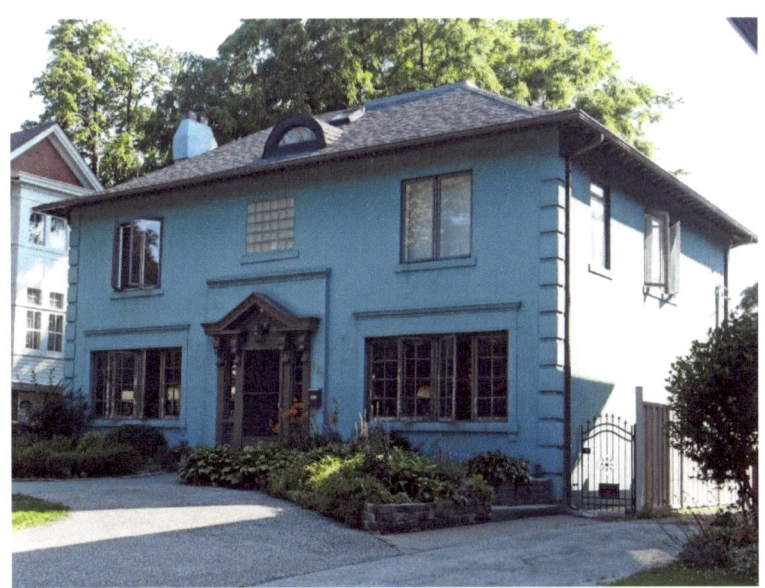

877 Victoria Avenue – Italianate, hipped roof, corner quoins, sidelights around front door

890 Victoria Avenue – 1911 - Italianate, four-square house, broad, columned porch, central oval window; dormer in attic

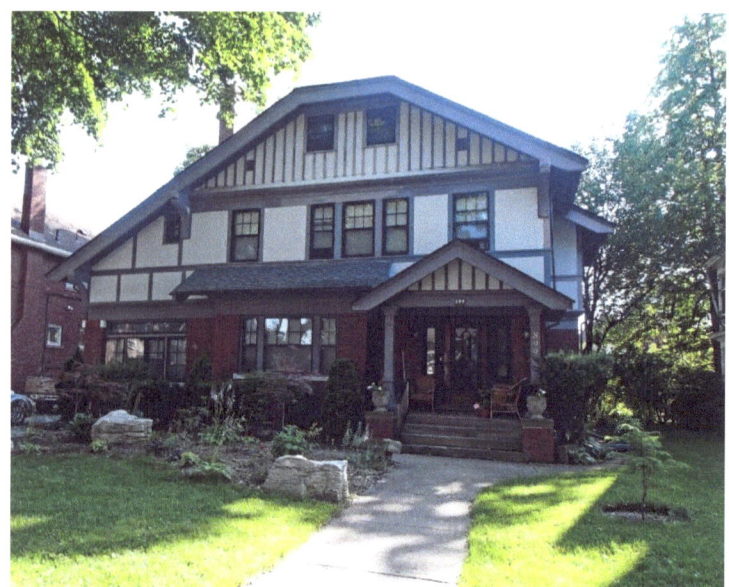

899 Victoria Avenue – 1912 - Arts and Crafts design featuring Tudoresque half-timbering, a prominent gabled porch, and an elaborate arched stair-landing window on the north side

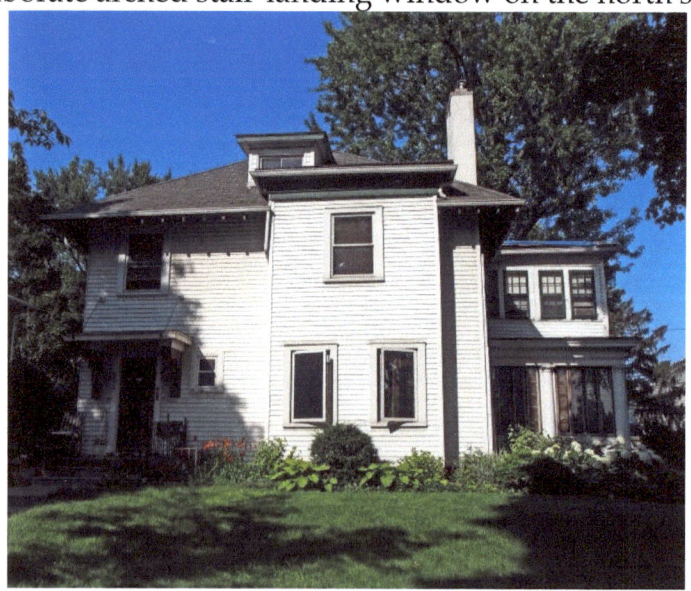

902 Victoria Avenue

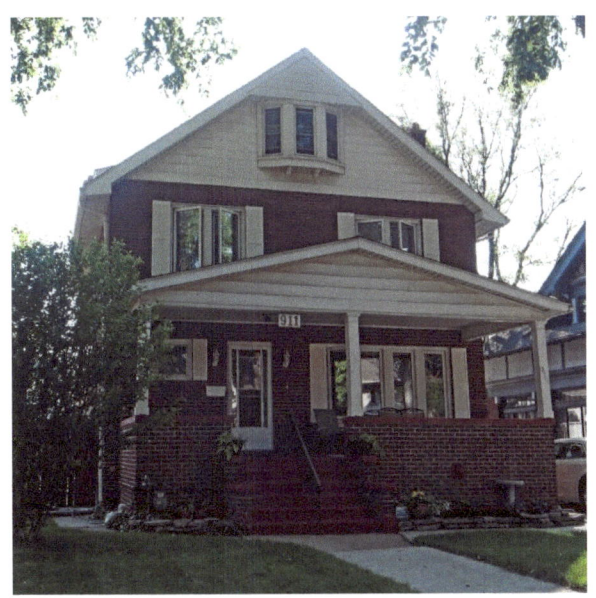

911 Victoria Avenue - vernacular

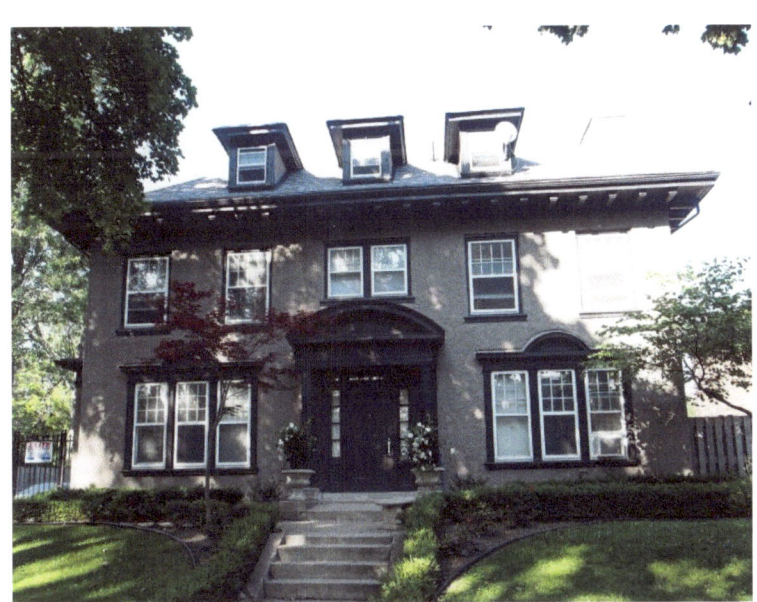

916-918 Victoria Avenue – William Donald McGregor House – 1919 – Colonial Revival – dormers

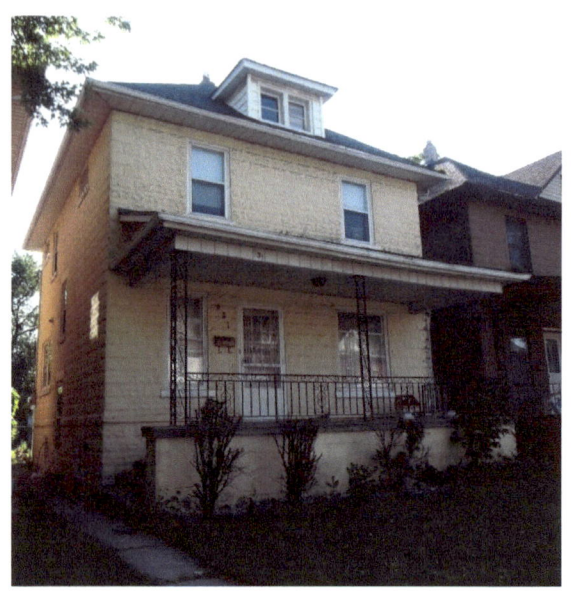

931 Victoria Avenue – Italianate - dormer

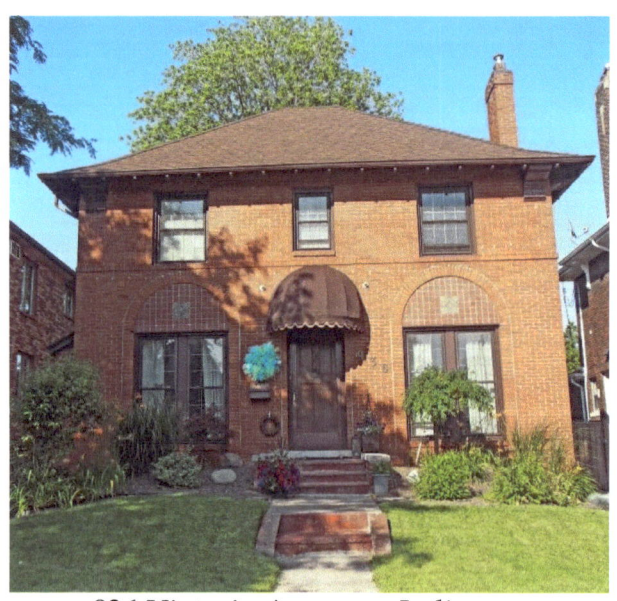

936 Victoria Avenue - Italianate

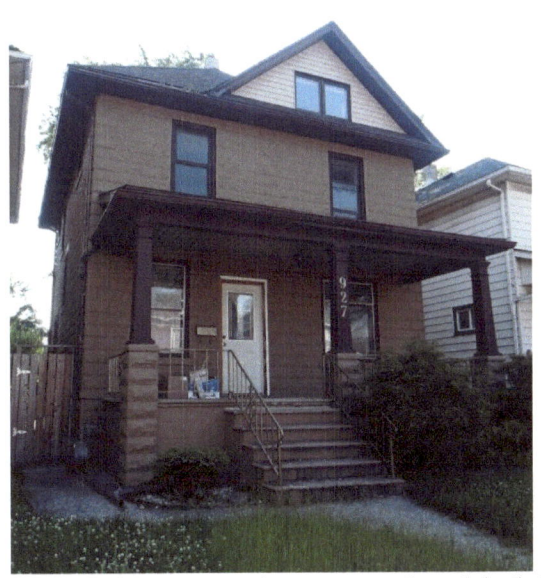

937 Victoria Avenue – Italianate with gabled dormer

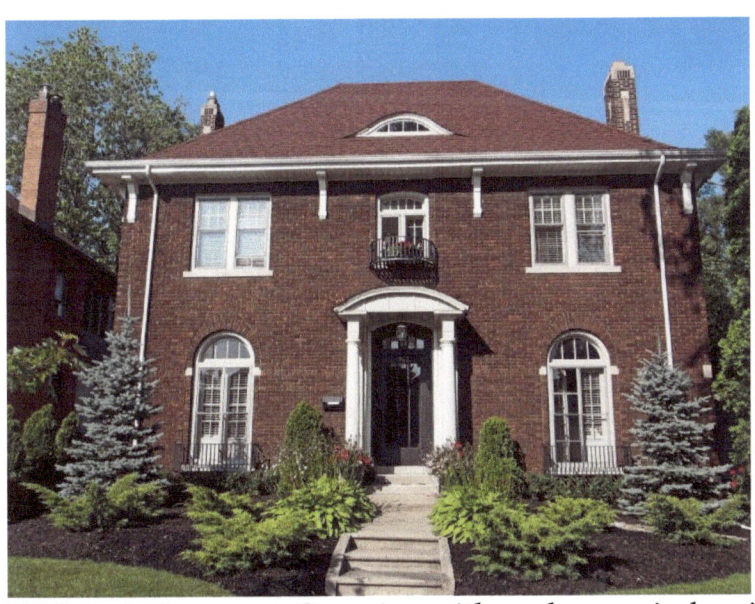

942 Victoria Avenue – Georgian with eyebrow window in roof, pillared entrance with rounded pediment

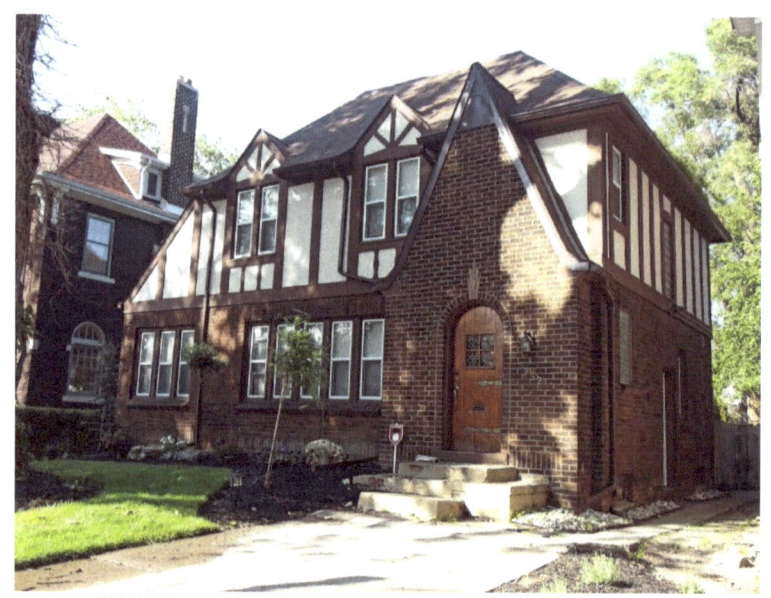
952 Victoria Avenue – Tudor Revival style

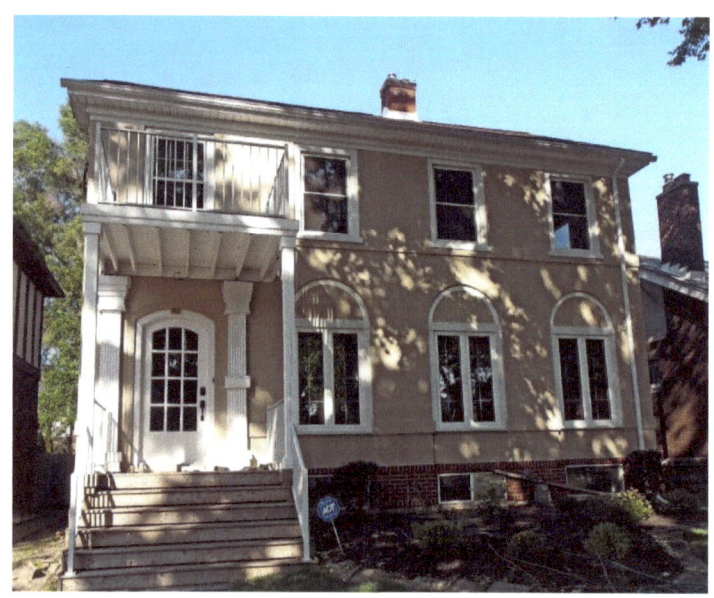
956 Victoria Avenue

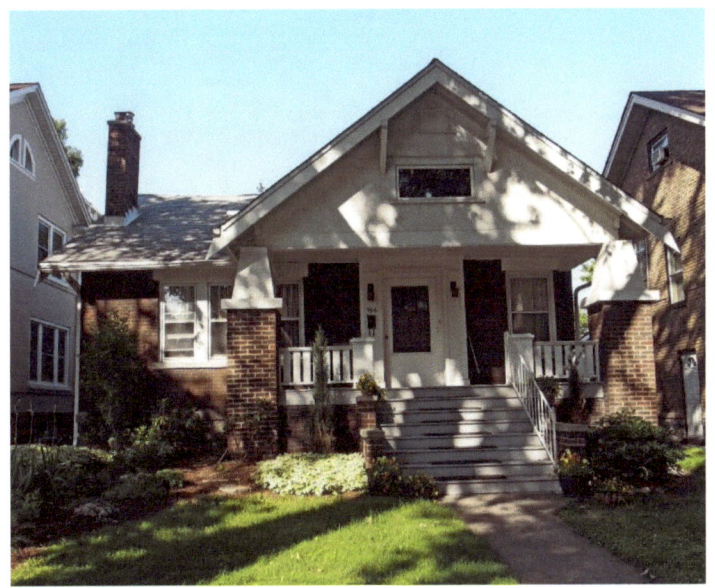

966 Victoria Avenue - vernacular

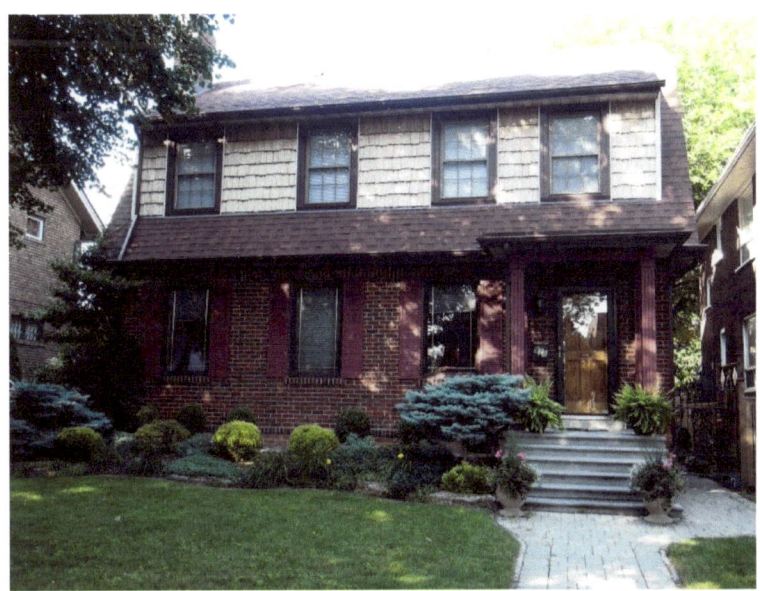

978 Victoria Avenue

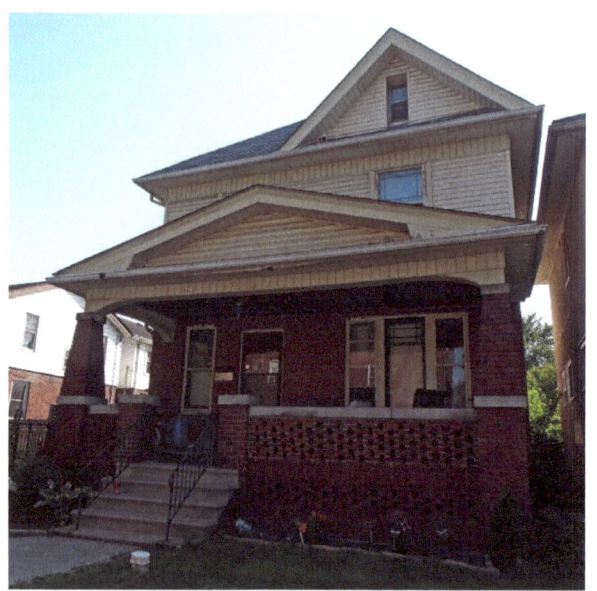

985 Victoria Avenue - vernacular

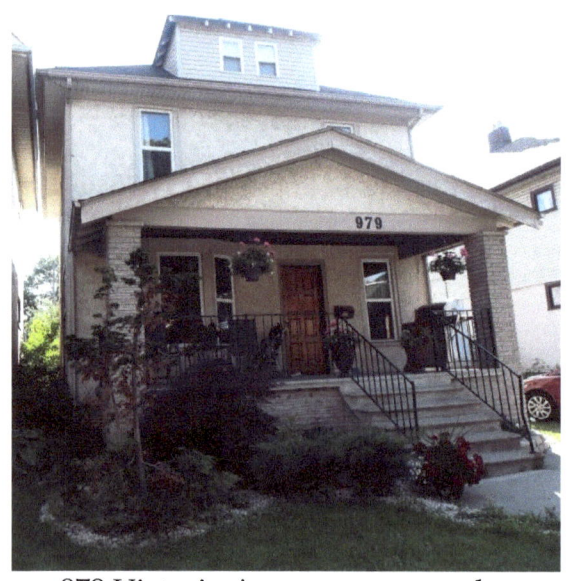

979 Victoria Avenue - vernacular

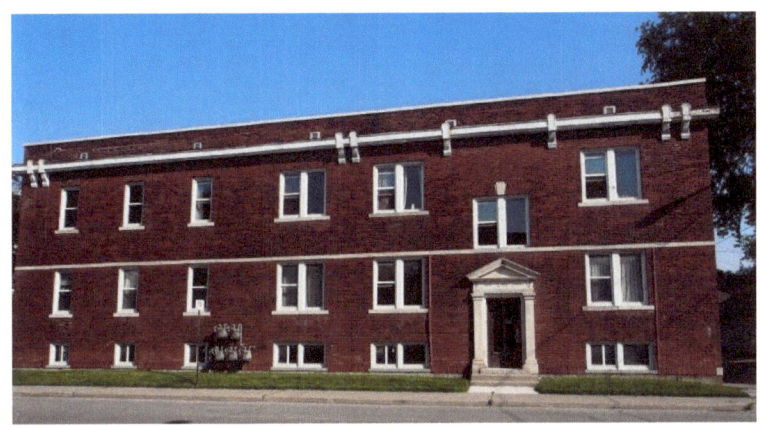

129 Dougall

 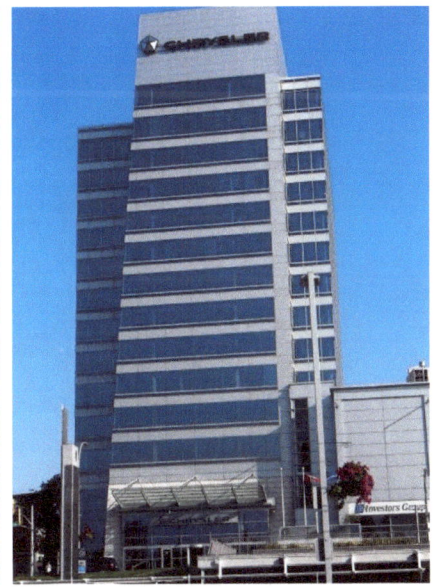

Chrysler Building

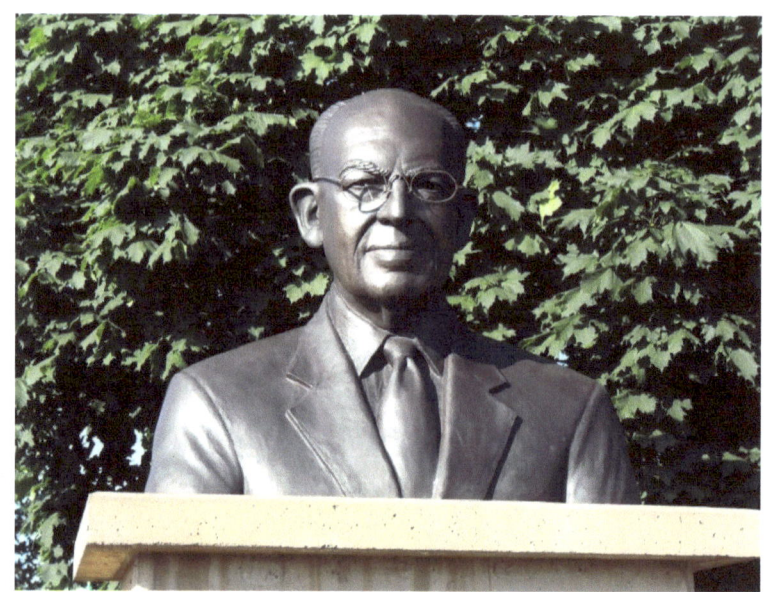

Herb Gray – House of Commons member
(See details on page 7)

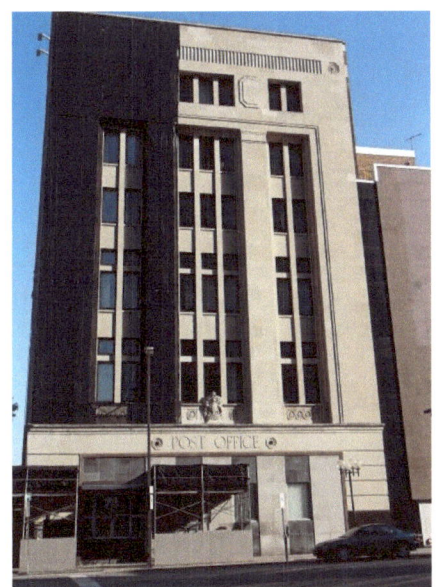

185 Oulette – Post Office - 1933

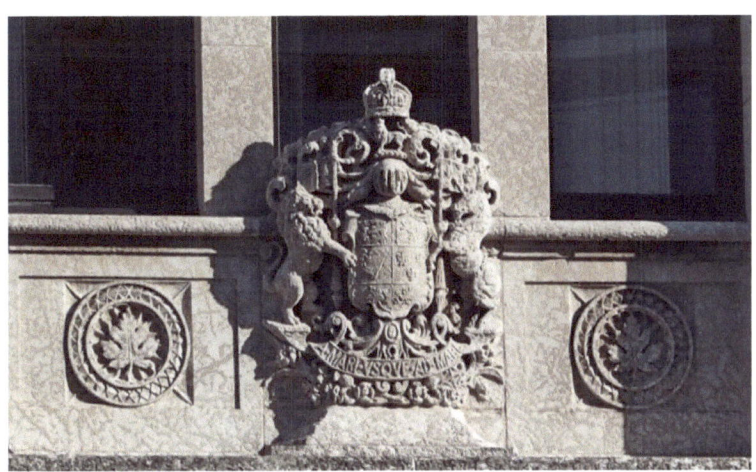

Market Place Murals

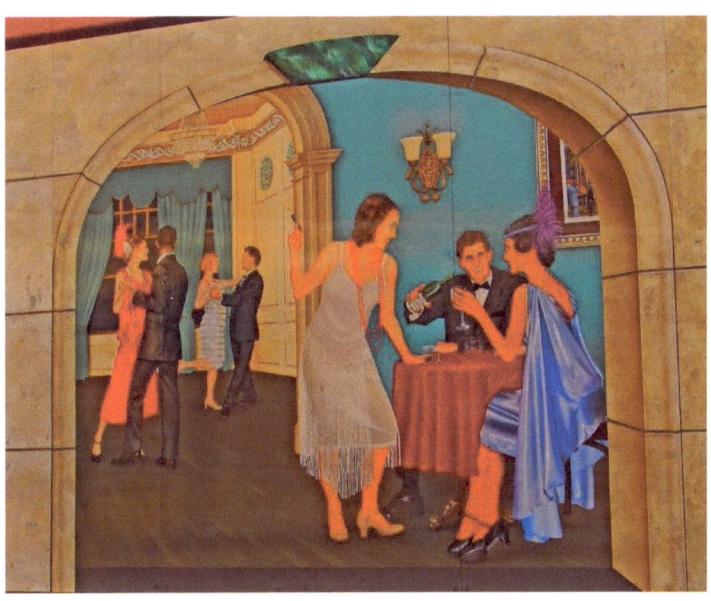

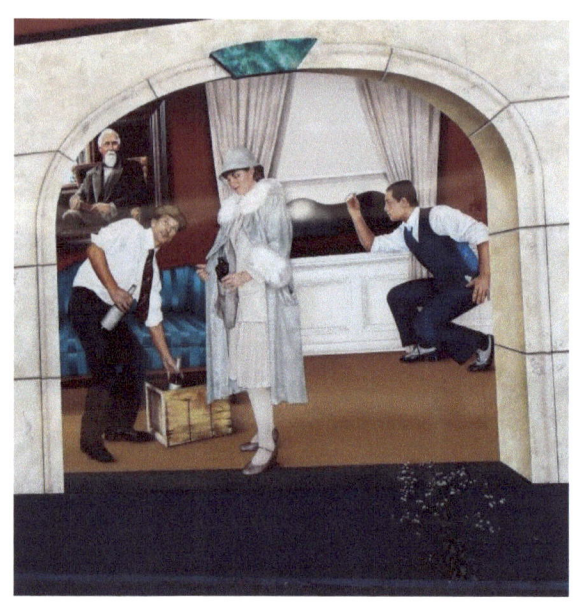

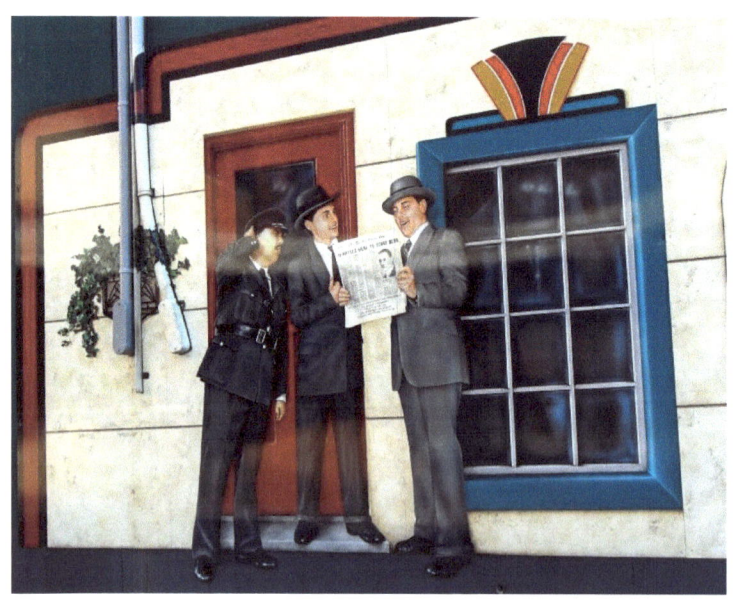

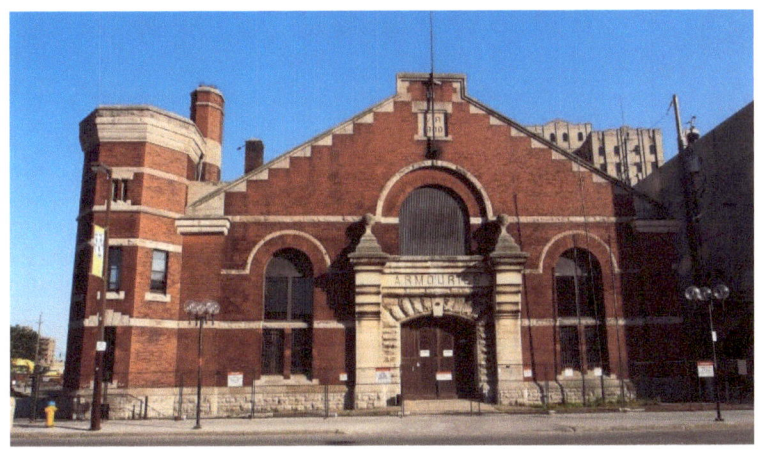

The Windsor Armouries is a two-storey, red brick Richardson Romanesque structure located on Freedom Way in downtown Windsor. It has a three-storey tower and was completed in 1902.

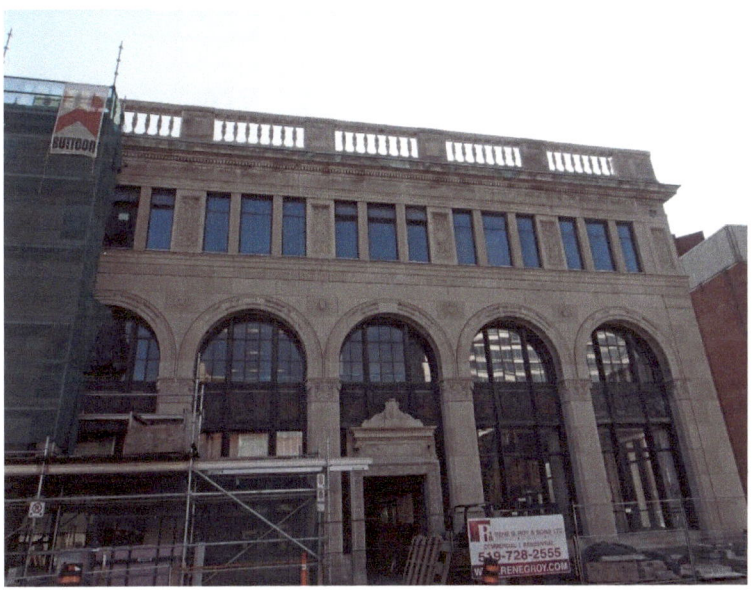

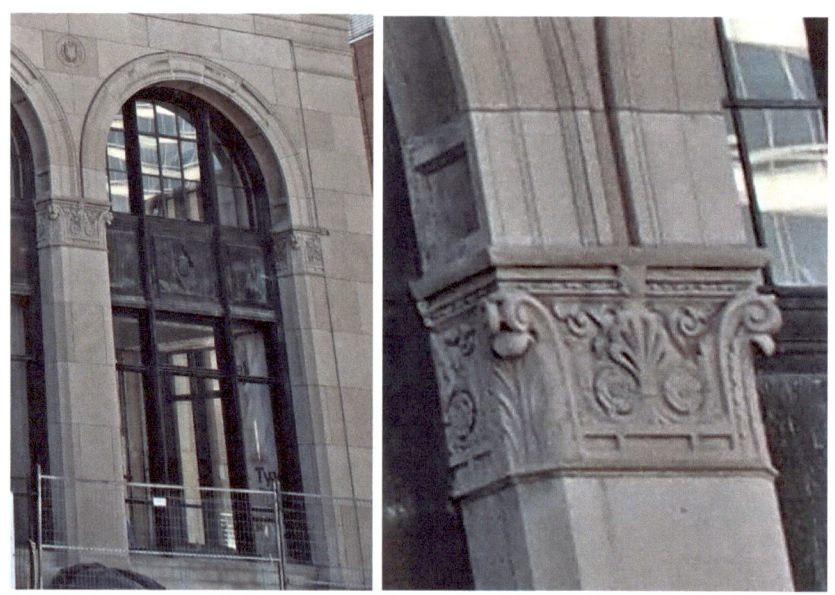

Romanesque style arch over windows, Corinthian capitals on pilasters

Carved doorway with hood

spindle decorated roof surround

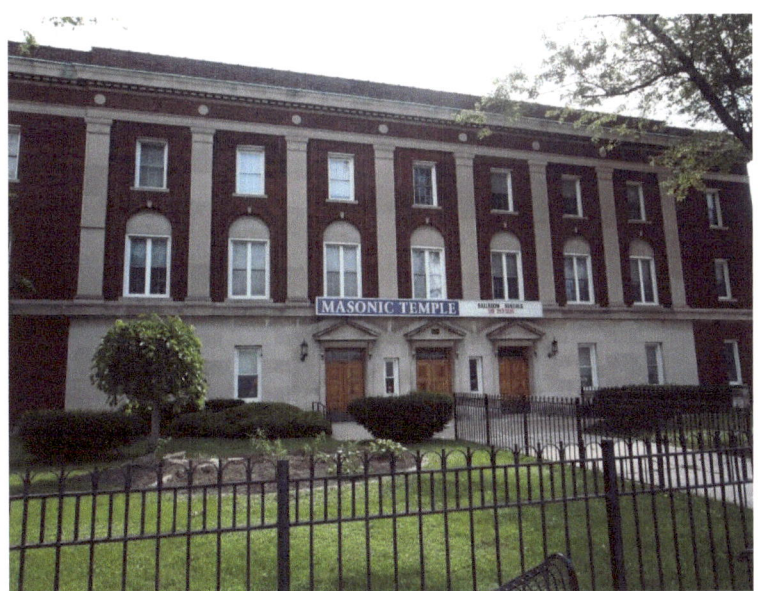

986 Ouellette Avenue – Masonic Temple - a large, three-storey, red brick Neo-Classical Revival style building, eight fluted two-storey stone pilasters with simple capitals, decorative stone rondels above pilasters, triangular stone pediments above doors; seven second-floor round-headed windows on the front façade, with keystones and radiating brick voussoirs around ornamental semi-circular panels; stone belt courses between the first and second floors, the third floor and attic, and the attic and parapet - completed in 1922

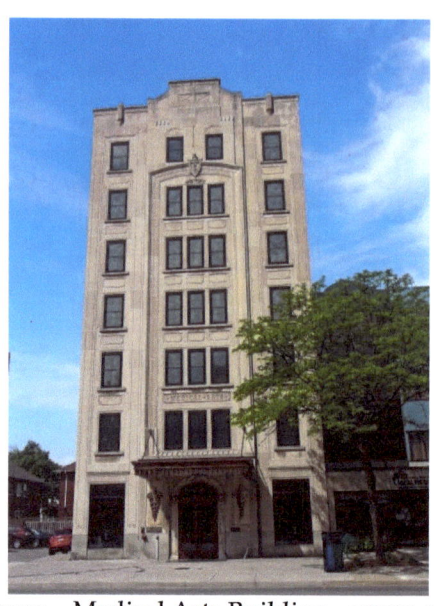

1011 Ouellette Avenue – Medical Arts Building - seven-storey Art Deco style commercial building of limestone and brick built in 1930 - characterized by classical symmetry and graceful lines; finely detailed limestone facade crowned by an angular parapet and enhanced by three vertical bays and an arched stone entrance sheltered by a bronze and glass canopy Corinthian pilasters flanking the entrance which features carvings of the traditional medical symbol of the caduceus, which also appears above the sixth-floor windows

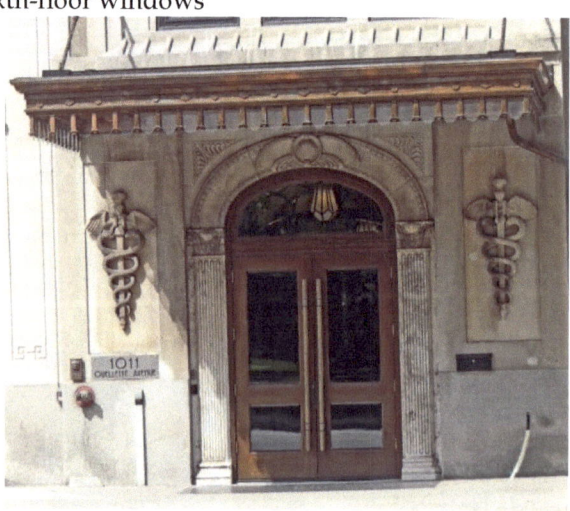

Detroit, Michigan

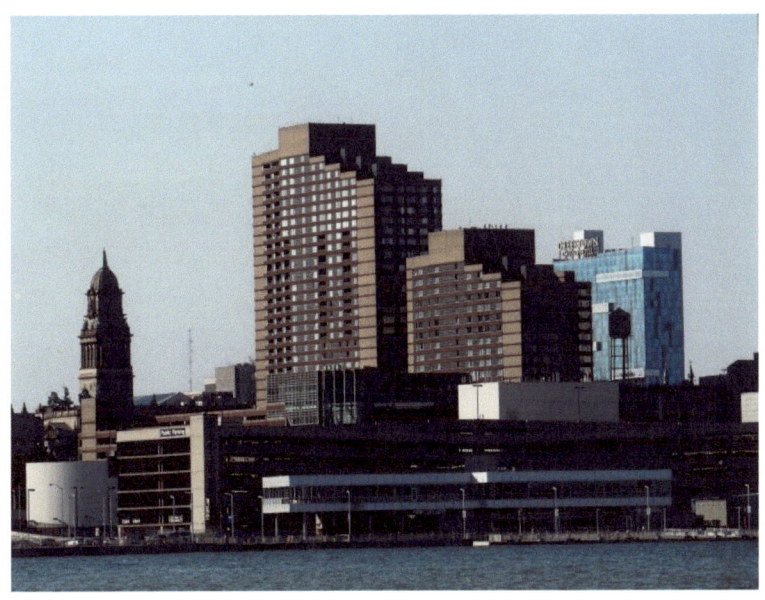

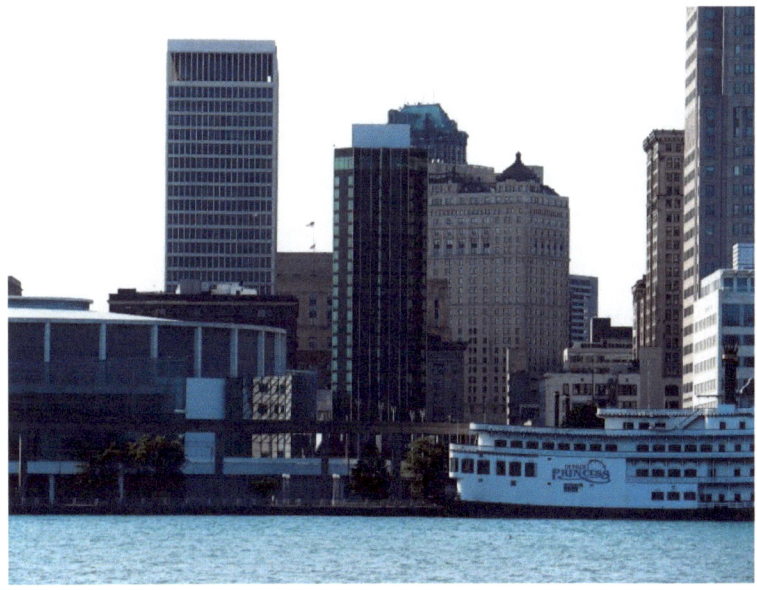

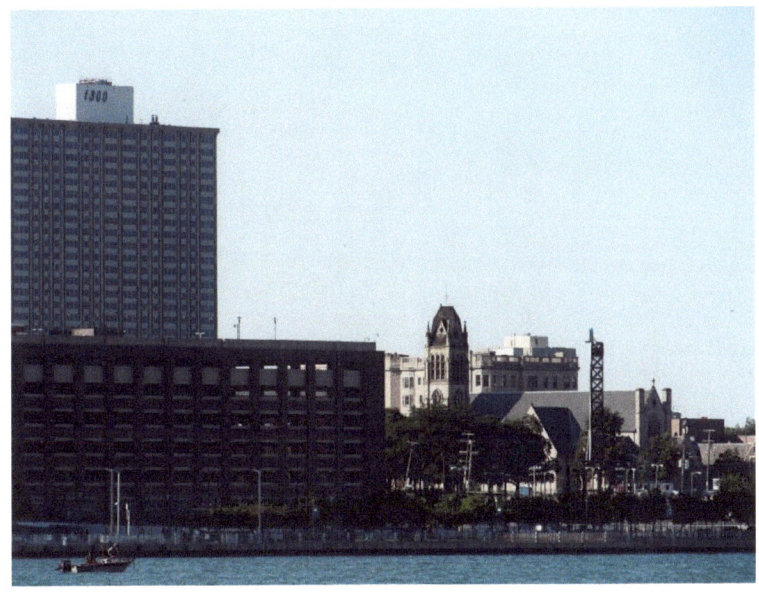

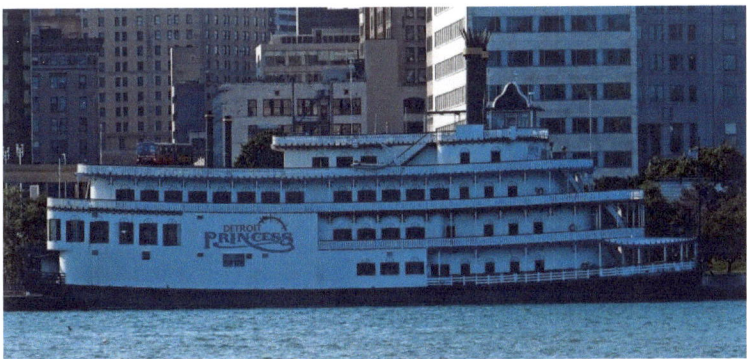

Detroit Princess

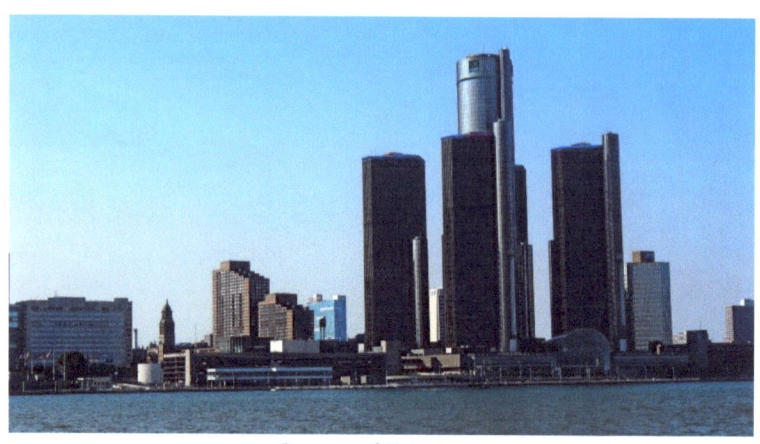
General Motors

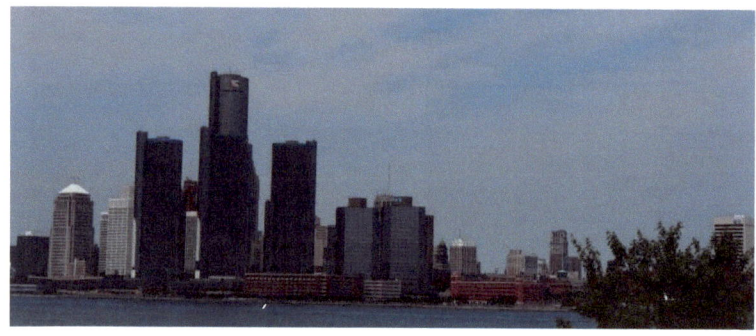

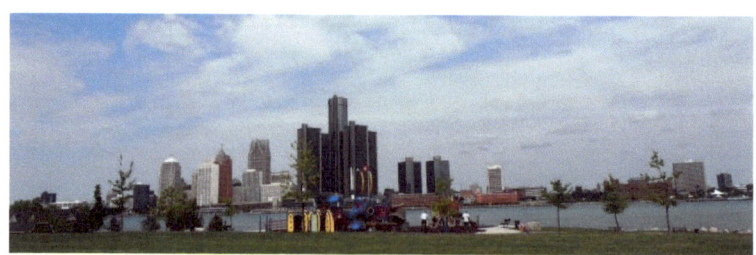

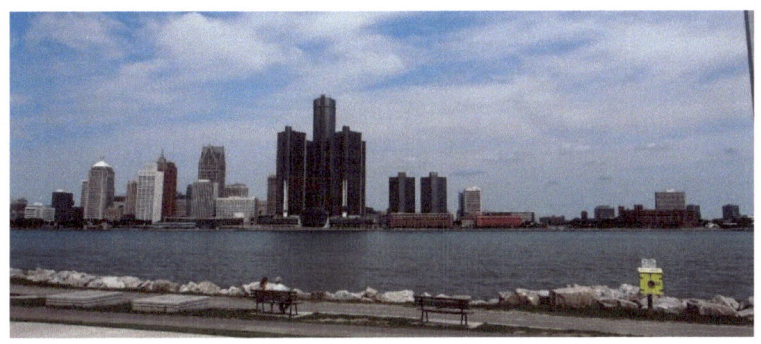

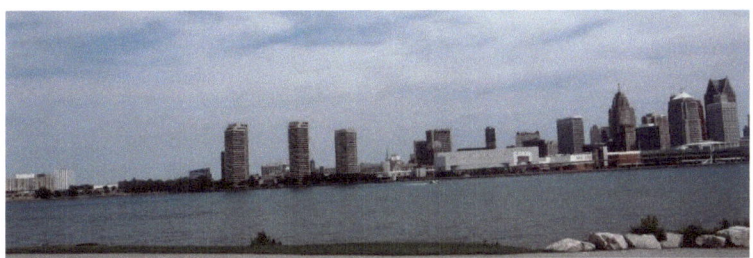

Architectural Terms

Bay Window: A window that projects out from a wall, in a semicircular, rectangular, or polygonal design. Used frequently in Gothic and Victorian designs. Example: 801 Victoria Avenue, see Page 17	
Brackets: a decorative or weight-bearing structural element which forms a right angle with one side against a wall and the other under a projecting surface such as an eave or roof. Example: 867 Victoria Avenue, see Page 22	
Buttress: a masonry structure built against or projecting from a wall which serves to support or reinforce the wall. In Canadian architecture, they are sometimes used for decoration. Example: Victoria Avenue, see Page 17	
Cornice Return: decorative element on the end of a gable. Example: 639 Victoria Avenue, see Page 12	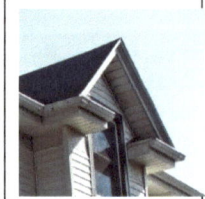
Dentil Moulding: an even series of rectangles used as ornamental decoration in cornices. Example: downtown, see Page 37	

Dormer: (French for "sleep") a gable end window that pierces through the plane of a sloping roof surface to create usable space in the top floor or attic of a building by adding headroom. Example: 825 Victoria Avenue, see Page 19	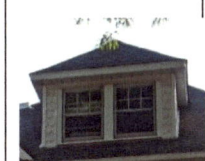
Entrance: The entrance encompasses the doorway and the inner vestibule or, in residential architecture, the covered porch. Example: 706 Victoria Avenue, see Page 13	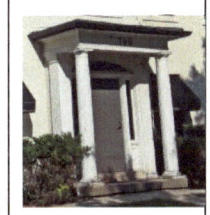
Gable: the triangular portion of a wall between the edges of a sloping roof. Example: 685 Victoria Avenue, see Page 11 **Jacobean Gable: :** the gable extends above the roofline Example: 815 Victoria Avenue, see Page 15	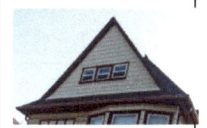 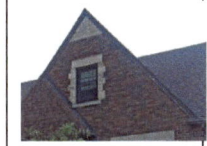
Gambrel Roof: a symmetrical two-sided roof with two slopes on each side; the upper slope is positioned at a shallow angle, while the lower slope is steep. It is similar to a mansard roof, but a gambrel has vertical gable ends instead of being hipped at the four corners of the building. Example: 742 Victoria Avenue, see Page 15	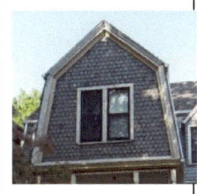

Hipped Roof: a roof where all sides slope downwards to the walls with no gables. Example: 877 Victoria Avenue, see Page 23	
Keystones and Voussoirs: a voussoir is a wedge-shaped element used in building an arch. A keystone is the central stone that locks all the stones into position, allowing the arch to bear weight. A keystone is often enlarged and embellished. Example: 986 Ouellette Avenue, Page 39	
Palladian Window: a large window that is divided into three sections with the centre section larger than the two side sections and usually arched. Example: 824 Victoria Avenue, see Page 19	
Pediment: a triangular section above the horizontal structure (entablature), typically supported by columns. The inside of the triangle is called the tympanum. Example: 824 Victoria Avenue, see Page 19	
Quoin: masonry blocks at the corner of a wall, often a decorative feature, usually larger or of a different colour than the rest of the wall. Example: 877 Victoria Avenue, see Page 23	

Sidelight: a window, usually with a vertical emphasis, that flanks a door, and is often used to emphasize the importance of a primary entrance. **Transom Window:** the light above the doorway, also called a fanlight. Example: 706 Victoria Avenue, see Page 13	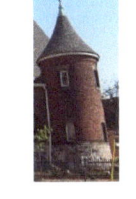
Turret: a small tower that projects from the wall of a building. Example: 405 Victoria Avenue - St. Andrew's Presbyterian Church, see Page 7	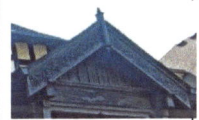
Vergeboard and Finial: also called bargeboards – hang from the projecting end of a roof and are often elaborately carved and ornamented. **Finial:** ornament added to the top of a gable, pinnacle, canopy or spire – a Gothic element. Example: 803 Victoria Avenue, see Page 18	

Building Styles

Art Deco, 1910-1940 - The Art Deco Style was developed for the French luxury market after World War I. Art Deco left its mark on everything from lamps and foot stools to purses and hair combs. The style was adopted in Ontario by wealthy and very fashionable patrons who wanted Art Deco detailing to make their buildings look lavish and exotic. Example: 1011 Ouellette Avenue, see Page 40	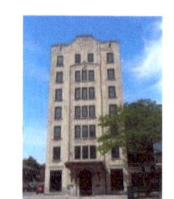
Arts and Crafts: The overlying theme - the house was based on the function of the house. Rooms were oriented to take advantage of the movement of the sun for warmth and light during daylight hours. Side entrances allowed for useable space on the front facade for light or garden use. Arts and Crafts houses have many of these features: wood, stone or stucco siding; low-pitched roof; wide eaves with triangular brackets; exposed roof rafters; porch with thick square or round columns; stone porch supports; exterior chimney made with stone; open floor plans with few hallways; many windows, some with stained or leaded glass; beamed ceilings; dark wood wainscoting and moldings; built-in cabinets, shelves, and seating. Example: 782 Victoria Avenue, see Page 15	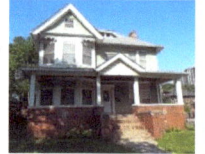

Edwardian, 1900-1930 – This style bridges the ornate and elaborate styles of the Victorian era and the simplified styles of the 20th century. Balanced facades, simple roof lines, dormer windows, large front porches, and smooth brick surfaces are its characteristics. Example: 639 Victoria Avenue, see Page 12	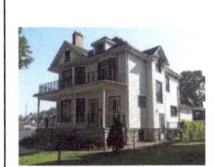
Georgian, before 1860 – This style began with the British King Georges in the 18th century. These buildings have balanced facades around a central door, medium-pitched gable roofs, and small paned windows. Example: 942 Victoria Avenue, see Page 27	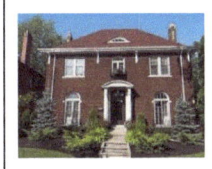
Gothic Revival, 1830-1890 – These decorative buildings have sharply-pitched gables with highly detailed verge boards, pointed-arch window openings, and dichromatic brickwork. It is a common style in Ontario. Example: 754 Victoria Avenue, see Page 13	
Italianate, 1850-1900 – It has wide-bracketed eaves, belvederes, wrap-around verandahs. Example: Victoria Avenue, see Page 9	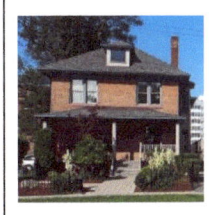

Neo-Classical (1810 - 1850) – This style was a direct result of the War of 1812. Many Upper Canadians returning from the war with the United States were second or third generation Loyalists who had inherited land and means from their forefathers. Once the conflict had passed, they had the money and the time to expand their holdings and indulge their architectural whims. Both residential and commercial buildings were constructed on the traditional Georgian plan, but they had a new gaiety and light-heartedness. Detailing became more refined, delicate, and elegant. Example: 706 Victoria Avenue, see Page 13	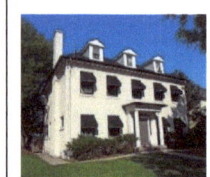
Neocolonial (also Colonial Revival, Georgian Revival or Neo-Georgian) architecture seeks to revive elements of architectural style of American colonial architecture of the period around the Revolutionary War which drew strongly from Georgian architecture of Great Britain. Architecture from the 18th and early 19th centuries in Ontario includes a wide assortment of detailing and ornament applied to a design centered around the fireplace and the source of water. Structures are typically two stories, have a symmetrical front facade with elaborate front doorways, often with decorative crown pediments, fanlights, and sidelights, symmetrical windows flanking the front entrance, often in pairs or threes, and columned porches. Example: 742 Victoria Avenue, see Page 15	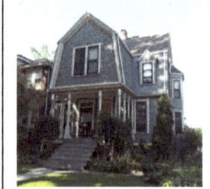

Queen Anne, 1885-1900 – This style is distinguished by an irregular outline featuring a combination of an offset tower, broad gables, projecting two-storey bays, verandahs, multi-sloped roofs, and tall, decorative chimneys. A mixture of brick and wood is common. Windows often have one large single-paned bottom sash and small panes in the upper sash. Example: 345 Victoria Avenue, Page 8	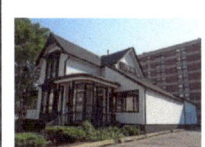
Romanesque Revival, 1880-1910 – This style hearkens back to medieval architecture of the 11th and 12th centuries with a heavy appearance, blocky towers and rounded arches. Example: 405 Victoria Avenue, see Page 7	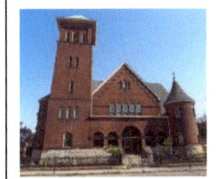
Tudor Revival – exposed timbers with stucco infill, multi-paned windows. Example: 952 Victoria Avenue, see Page 28	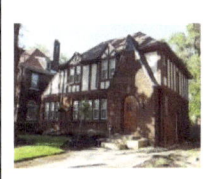
Vernacular/Traditional Mode 1638 - 1950 Influenced but not defined by a particular style, vernacular buildings are made from easily available materials and exhibit local design characteristics. Example: 468 Victoria Avenue, see Page 9	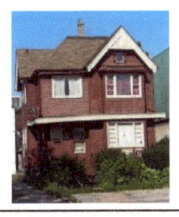

www.ingramcontent.com/pod-product-compliance
Lightning Source LLC
Chambersburg PA
CBHW040812200526
45159CB00022B/498